igloobooks

Published in 2014
by Igloo Books Ltd
Cottage Farm
Sywell
NN6 0BJ
www.igloobooks.com

HUN001 0314
2 4 6 8 10 9 7 5 3 1
ISBN 978-1-78197-964-8

Written by Jennifer Sanderson

Printed and manufactured in China

Contents

Elements of art

Art is all around us. It is in the beautiful painting that hangs on the wall and it is in the design of our clothes and shoes. Art can be aesthetically pleasing such as a striking sculpture or drawing, or it can be functional such as the chair on which you are sitting.

Elements of art

All art, whether it is functional or designed to illicit an emotional reaction, contains certain elements. These elements of art are the building blocks that artists use, and without them, art would not be possible. The building blocks are:

• Line: a line is a continuous mark that is made on a surface by a moving point. Without line, we would not be able to draw shapes, objects or symbols: art would be impossible.

• Shape: this is an object that has only two dimensions: length and width. Geometric shapes such as circles, rectangles, squares and triangles have clear edges, while organic shapes have natural, less defined edges.

• Form: this is a three-dimensional object. Sculpture, by its nature, works with forms but those artists who draw or paint in two dimensions, seek to give their art a third dimension, which is depth.

• Space: this refers to distances or areas around, between or within the components of a piece. Space can be positive (white or light) or negative (black or dark), open or closed, shallow or deep and two-dimensional or three-dimensional. Sometimes space isn't actually within a piece, but the illusion of it is.

• Texture: is used to describe the way a three-dimensional work feels when touched, or the visual 'feel' and appearance of a two-dimensional work.

• Value: refers to the lightness or darkness of a colour. This is a crucial element when drawing with pencils or charcoal because artists use the grey of the pencil or blackness of the charcoal to create light and dark values.

• Colour: colour is produced when white light, striking an object, is reflected back to the eye.

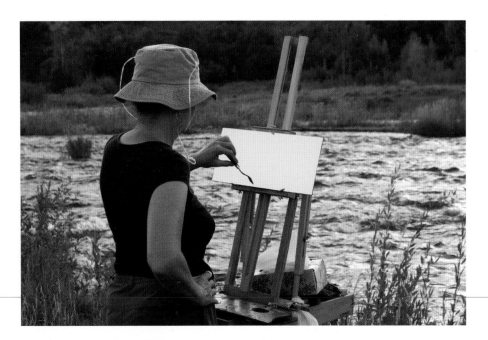

Using building blocks to paint

The aim of this book is to help you to feel confident when using watercolours, whether you are using them to create a visually appealing piece that gives pleasure, or a piece that can be used as a starting block to create another work of art. Often people see painting with watercolours as a dull craft using little more than colour washes to create a painting. However, washes are just a small part of the process. Watercolours can be a vibrant and flexible medium, especially if you are prepared to experiment with different painting tools, from painting with sponges and twigs, different paper, and different painting techniques. This book will teach you how to use the basics elements of art as well as different watercolour techniques, to improve your painting skills and create a work of art, which you will be proud to hang on a wall.

Watercolour painting

Watercolour painting is sometimes seen as an insipid relative of oil painting. However, it can be a richly rewarding medium if you use your imagination and are willing to experiment with different techniques.

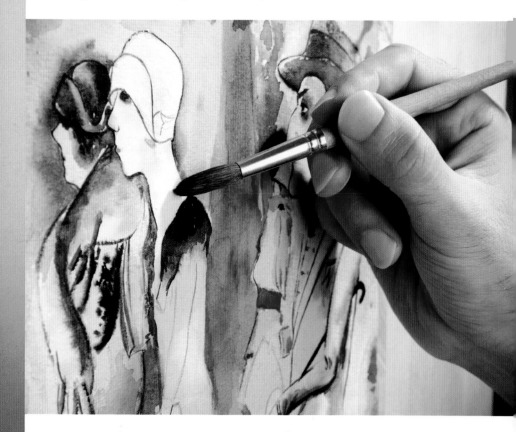

What is watercolour painting?

Just as the name suggests, watercolour painting is painting that is based on water. Water is mixed with pigments to create paints that can be either solid or liquid in form. When applied, watercolour paint has a striking, transparent look.

Is watercolour for you?

If you're interested in painting, there are several different mediums to choose from, from acrylics and oil paints to watercolours. How do you know whether watercolours are the right medium for you?

• Watercolour is inexpensive. Unlike other mediums, you do not need a lot of additional equipment to begin watercolour painting. You'll need paper, paints, brushes and water – and that's all! Once you are more experienced, you can buy more expensive materials, but for now, buy the best equipment you can afford.

• Do you want to create an organic look? Using the wet-into-wet watercolour technique will give you beautiful organic shapes that are hard to achieve with another medium.

• Do you prefer to mix your colour on the canvas or before you paint? Most of the techniques used in watercolouring use paint mixed in a mixing well. The advantage of this technique is that you can test your colour before you paint. You then know that when you paint, the colour will be right.

• Are you a 'paper person'? If you like to paint only on paper, then watercolouring is for you. Other mediums, such acrylic paints, can be applied to just about anything, excluding paper!

• Do you like to re-work and change your paintings? Watercolour paints are quite unforgiving and it is very difficult, and most often impossible, to change the paint once it is on the paper. If you are someone who paints and repaints, watercolouring is not for you.

• Do you like to be in control? Watercolour paints can be unpredictable and your end result could be quite different from what you originally had in mind. While for some artists, the 'flowing' nature of watercolours is what they love best, for others, this element of surprise is not enjoyable.

Start slowly

If you've considered the above factors and decided that watercolours are definitely your preferred medium, it's time to get started! However, remember that any new hobby takes time to perfect, and watercolour painting is no exception. It may take several attempts to paint a quality picture, but one beautiful picture will make this worthwhile.

7

Getting to know watercolours

Artists' tools

There are several tools that you will need to paint with watercolours. Brushes, paper, and of course your paints. You'll also need extra equipment, such as a palette and storage for your finished artwork.

Brushes

Watercolour brushes are softer than those used for oil and acrylic painting. There are many different kinds of brush for you to choose from. They vary in size and shape and their bristles may be made from either natural or synthetic fibres. Brushes made from natural fibres, such as sable, are typically much more expensive than their synthetic counterparts. Sometimes, manufacturers will mix sable bristles with cheaper hair, such as squirrel or camel hair, to reduce the cost. If you are choosing synthetic brushes, you will need those with softer bristles.

Brush size

Brushes are usually numbered – for example, a range of brushes may start with No0000, which is suitable for only the finest work, and end with No20, which is very large. Each manufacturer's number system may be slightly different, so No3 in one range may not be the same size as No3 in a different range. Flat brushes may be numbered by the total bristle width.

Brush shape

Brushes vary in shape, depending on the type of mark you want to make. The most commonly used shapes include round, flat or chisel headed, filbert and fan. Round brushes have a rounded ferrule (the metal sleeve that joins the bristles to the brush handle). Large round brushes are used for laying a wash and a wide expanse of colour. Flat or chisel headed brushes have a flattened ferrule with a square-cut bristle head. The wide bristles are good for applying paint in short dabs, while the narrow bridges are better for finer details. Filbert brushes are somewhere in between round and flat brushes. They have a flattened ferrule with tapered bristles and are especially versatile. Fan brushes have splayed out bristles and are used for blending colours.

Brush care

Rinse your brushes well each time you use them but never leave them standing in water. At the end of a painting session, wash your brushes well in warm, soapy water then rinse them in clean water. Reshape the bristles and store them upright with the handle-end down.

Paper

Choosing the right type of paper for your artwork is just as important as choosing your paints, because the type of paper you work on can greatly influence how your painting looks. The texture, weight and colour of paper should be carefully considered before you start to paint.

Texture

The texture of paper affects how paint is absorbed. Rough paper is heavily textured and is suitable for bold brushwork, but is not the best choice for beginners because it makes the washes very unpredictable. At the other end of the scale, hot-pressed (HP) paper has a very smooth surface as is often labelled as such. Due to the smoothness of this type of paper, the colour often stays on its surface and so can be manipulated more easily. HP paper is best for combining watercolour and pen-and-ink, and watercolour and coloured pencil. Somewhere between these two types of paper is cold-pressed, or NOT paper. This paper has a noticeable texture and is the best choice for most watercolours.

Weight

The weight of paper determines its thickness and absorbency.
Paper weight is given in grams per square metre (gsm) or pounds (lb).
Lightweight paper is about 190 gsm (90 lb), medium paper weighs
around 300 gsm (140 lb) and heavy paper is around 638 gsm (300 lb).
Any paper that is 200 gsm (110 lb) or lighter will absorb paint and so
tends to buckle quite easily. This makes the paper unsuitable for
beginners. The most commonly used paper is 300 gsm (140 lb).

Colour

In addition to the texture and weight
of your paper, the colour is also
important. Many artists favour a
bright white paper. White paper
reflects light back through the paint,
which gives it translucence. White
paper also serves as the whitest and
brightest part of the painting. For
works of art that contain a lot of white
using white paper is advantageous
because the paper can simply
be left unpainted.

Buying paper

A pad of watercolour paper is generally the most convenient
to buy. Usually the cover of the pad shows the characteristics
of the paper. If you are not sure what kind of paper you want
to paint on, most art supply shops will sell individual sheets of
paper. Unfortunately, individual sheets may have other people's
fingerprints on them, left behind as they examined the paper. Peoples'
fingers have natural oils that will mark paper. If you intend to buy just
a single sheet of paper, try to select one from the bottom of the pile.
Although most modern paper is now acid free, it still pays to check that
paper is acid free before you purchase it. Acid will slowly destroy your art.

Paints

Watercolour paints are made from mixing a finely ground pigment with a water-soluble gum binder or gum arabic solution. In the past, honey or sugar was added to the paint to make it more soluble, but today, glycerine is used instead. Today, paints come in pans or tubes with each having pros and cons.

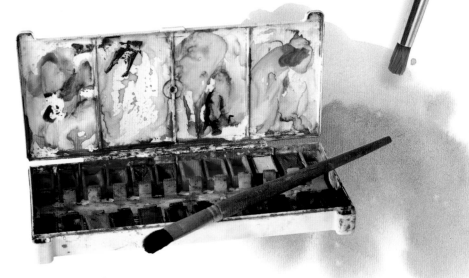

Pans of paint

Pans are small, square cakes of pigment. They are either sold individually or in a paint box as a collection of different colours. Pans tend to be cheaper than tubes but can easily dry out, so in the long run it may be worth investing in tubes. To pick up the colour from a pan, you need to dampen your brush and move it over the colour.

Tubes

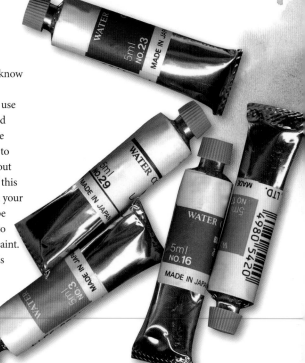

Generally, tubes are recommended once you know how to use and mix the colours in your paint box. Each tube contains a different colour. To use the colour, a small amount of paint is squeezed onto a clean, dry palette. Being able to squeeze the paint out of the tube means that it's easier to keep these paints clean but you may squeeze out too much colour and end up wasting paint. If this does happen, you can simply wet the paint on your palette and carry on using it. Tube paint can be cumbersome to work with because you have to stop painting to access the tube and mix the paint. However, it is easier to mix than pans and so is more suitable to painting larger areas.

Sunshine Yellow

Water Colours

Permanence A
Series 3

Sunshine Yellow • Sunshine Yellow
Sunshine Yellow • Sunshine Yellow

Manufacturer's name for colour

Printed colour

Lightfastness rating

Price Group

Pigment Name (in multiple languages)

Buying paints

There are several different brands to choose from. Whether you are buying larger tubes or small pans, it is better to have a few, better quality paints than more cheap paints. School paints are usually the cheapest watercolour paints but not the best quality. This is because they have a filler added to the pigment, which means that the colours they produce are not great.

Other materials

Once you have bought your paper, brushes and paints, and have access to water, you will need little more equipment to start painting. However, palettes, brush holders, brush boxes, easels and storage folders all make the process of painting much easier. In addition to these, you'll also need pencils and sketchpads to plan your work.

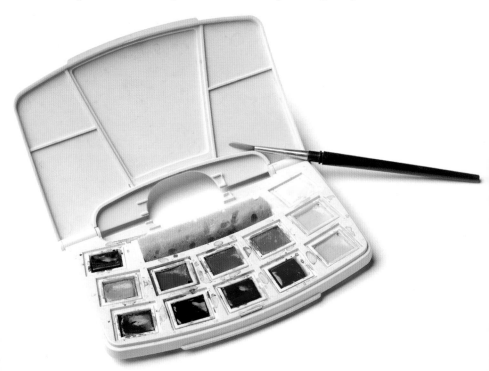

Palettes and palette boxes

While paint boxes usually have lids that are marked with palette divisions, if you are using tubes you will need a palette on which to mix your paint. Because mixing paint is such a vital step in the watercolour process, you need a palette to make this process as easy as possible. Palettes with mixing wells are the best type of palette to use because they allow you to keep your colours separate. To see the colours, a white palette is useful. Although you can buy plastic palettes, those made from porcelain are easier to clean and are preferred by many artists.

16

Brush holders

There are several types of paintbrush holder in which to keep your brushes while painting. They can be manufactured from a range of materials, from plastic and wood to Perspex. Whichever you choose, your brushes should stand upright and the bristles should not touch the bottom of the holder. Some holders have lids that seal so you can carry water in them, too. These are especially useful when painting outdoors. In addition to these holders, you can also buy brush storage boxes that are great for carrying and preserving your brushes. They come in a range of sizes so you need to consider how many brushes you have and their sizes before you buy one. If your box is too big for the quantity of brushes you have, the brushes may roll around in the box and become damaged.

Easels

Like any method of painting, watercolour work requires a firm surface on which to attach your paper. You can attach paper to a hard piece of wood with tape, clips and tacks so that your paper doesn't shift around or crinkle when you start painting. If you want to paint regularly, an easel is a good investment. Small tabletop easels are great for indoor use but are not very practical when painting outdoors. For outdoor use, a metal or box easel is preferable. Both have adjustable legs and can be set up on any flat surface. Box easels are especially useful because you can use them to store your paints and brushes while painting outdoors.

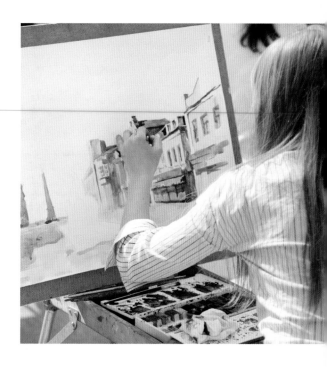

Storage folders

Art folders come in various shapes and sizes and are made from different materials. The simplest are made from cardboard, while more sophisticated folders are made from hard plastic. Some folders also come with plastic sheaves in which to put your art. These are great for viewing your work, too.

Support materials

While it is obvious that you will need paper and paints to start watercolour painting, there are some support materials that you will find useful, too. These include:

- Pencils and pens: you will need these so that you can draw your subject before you paint it. You won't need a full range of graphite pencils, but a selection of different leads that includes a few hard leads and some softer ones will be useful.

- Pots and jars: these are useful for holding water, your brushes and pencils and pens.

- Craft knife and blades: you'll need to cut your paper and a blunt knife will leave a torn and ragged edge, so always have a new blade to hand.

- Rulers: these will be used to measure different objects so you will need a range of different lengths.

- Kitchen towels and old rags: these will help to mop up any water spills.

- Adhesive tape: a waterproof kind is best. You will use this to stretch your paper before you paint.

There are also some materials that you will find useful once you are more experienced. These include:

- Gum arabic: This is used for sticking paper.

- Hair dryer: This can help to speed up the drying process if you are superimposing colours. However, never leave the dryer near water and unplug it as soon as you have finished using it. Never rest the dryer on paper.

- Alcohol: this can also be used to speed up the drying time.

- Glycerine: this slows down the drying process.

- Masking fluid: this is used to mask out shapes.

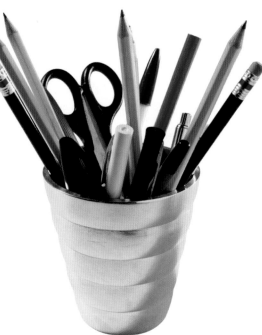

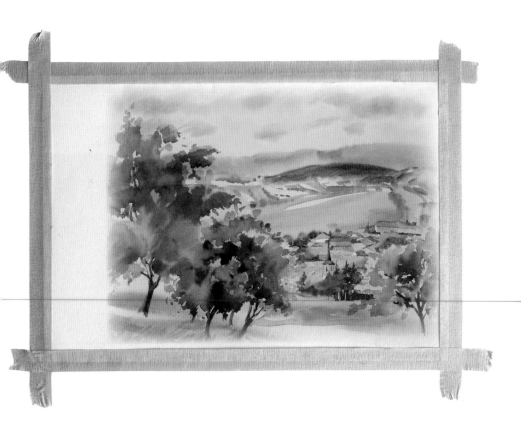

Stretching paper

When you paint with watercolours on paper, the paper often crinkles. To help eliminate this, it is advisable to stretch your paper before you start. This is a simple but necessary procedure. To stretch paper, place your paper on a wooden support and wet it with a sponge. Once the paper is soaked, apply waterproof tape around the edges to keep it in place. When the paper dries, it will stretch. Cut around the inside edge of the tape to remove the paper. If you're stretching paper one sheet at a time, remember to choose a piece of paper larger than you need to paint your subject because you will lose the width of your tape when you cut around it.

Perspective

One of the challenges of painting is to create the illusion of three dimensions. Without perspective, this is impossible to do. Perspective is a method of representing subjects and parts of the subject so that they recede in the distance and appear to be further away than they actually are.

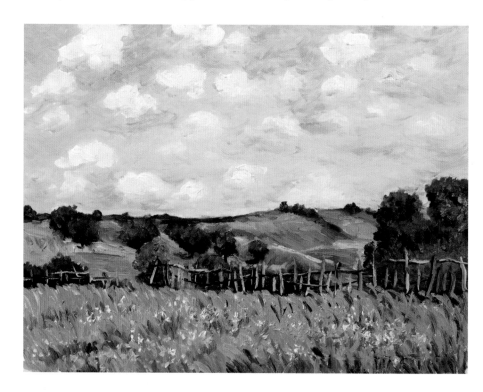

Linear perspective

Sometimes called geometric perspective, linear perspective is usually what people mean when they talk about perspective. To understand perspective, you need to also understand some basic terminology:

• Horizon line: this is an imaginary horizontal line drawn at eye level. The horizon line divides your line of vision when you look straight ahead of you.

• Vanishing point: this is the point on the horizon line at which the straight lines of an object converge and seem to disappear or vanish.

Placing your subject

Where you place your subject in relation to the horizon line in your painting will have a great effect on the composition of your artwork. For example, if your painting is at eye level, the viewer will feel as though the painting is an extension of his or her space, and he or she will view the image in relation to his or her body. The viewer's eye is naturally drawn towards the horizon line, therefore a high eye level will focus attention on the middle and near areas of your painting. A low eye level means that more attention will be focused on the rear area of the painting, allowing more space to draw the sky. Having a large area of sky can help to create a specific mood in a painting.

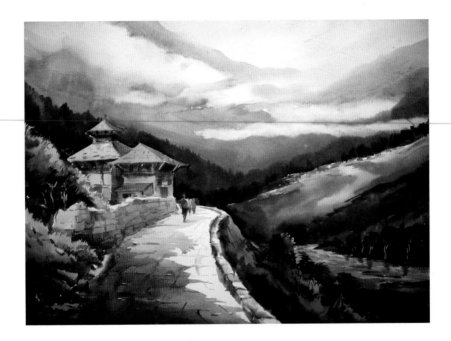

Achieving linear perspective

Linear perspective can be achieved by using one-point, two-point and three-point perspective. In one-point perspective, the frontal face of an object is closest to the viewer and the edges converge and disappear at a single vanishing point. In two-point perspective, it will seem as though you are looking at an object or scene from one corner, with two sets of parallel lines moving away from you. Because each set of parallel lines has its own vanishing point, in two-point perspective, there are two vanishing points. Three-point perspective is most often used in painting buildings and other structures that are viewed from a low or high eye-level. If the subject of a painting is above the horizon line, the view will be looking up at the subject. This will make a building seem very tall. Similarly, the viewer will be looking down at the subject if the subject is painted below the horizon line. Three-point perspective uses three sets of parallel lines and three vanishing points.

Composition

Artists position things in their paintings to achieve balance , so all the component or individual parts work together. This 'balance' is composition. A well-balanced painting will captivate the viewer.

Paper shape

One of the most basic aspects of composition is choosing the size and shape of your piece of paper. To use the correct sized paper, everything must fit on the paper but the paper cannot be too large – if it is, the viewer's eyes will not be able to focus on the painting. The shape of the paper can be landscape or portrait, horizontal or vertical. Again, everything needs to fit on the paper within the chosen size.

Focusing on focal points

Once you have chosen the size and shape of your paper, you need to decide where to draw the focal point. If you position your focal point exactly in the centre of your piece of paper, or if you divide your paper in half with a tall object in the middle, your painting will have very little impact. Similarly, if the same sized objects are placed equidistant on either side of the centre line, your painting will be rather boring.

Achieving balance

To achieve a good balance, one of the most commonly used theories for positioning a focal point is called the 'golden ratio' or 'golden mean'. The golden ratio was discovered by the Greek mathematician, Euclid. He worked out that a sequence of numbers (3, 5, 8, 13, 21…) gave a series of ratios. This means that if a line is drawn by combining two successive numbers in the ratio, for example 5 and 8 to give a line of 13, and divided into the two component lengths (one of 5 and one of 8), the ratio of the smaller part (5) to the larger part (8) is the same as the ratio of the larger part (8) to the whole (13). So: 'C' (A+B) is to 'A' as 'A' is to 'B'.

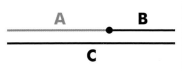

If you divide your paper up according to the golden ratio, where the vertical and horizontal lines of the ratio intersect (usually a third of the way in and a third of the way up or down), you will find one of the better places to position your focal point. Once you know where to paint it, you need to make the focal point stand out. The focal point should also be the largest item in the painting. In this painting, the teapot is the focal point. Not only is it painted in the right place, it is also the largest item on the paper. The fact that the artist has chosen to paint a white teapot is also important because the white really stands out next to the green of the background, giving the focal point prominence. The red of the apple helps to keep the balance of the composition because it provides the viewer with a second focal point, which helps to move his or her eye around the painting.

Choosing a subject

Finding inspiration

Often, being unable to find a subject is the hardest part of beginning a painting. Like authors who experience writer's block, many artists struggle to find the inspiration to get started. Once you feel inspired, finding a subject to paint should be easier.

Tidy workspace

Although it is a matter of personal taste, for many people trying to concentrate or indeed feel relaxed and creative is difficult when surrounded by mess. If you're lucky enough to have an area dedicated specifically for your painting, it may help if it is kept tidy and if your materials are kept in an orderly way. If you have not organised your paper and brushes, beginning to paint can be extremely difficult. If you paint in a space that is used for other things, such as at a dining-room table, try to remove anything that is not related to your painting. This will help to focus your mind on painting and that alone.

Arty jobs

If you're workspace is tidy, you can get everything ready to start. Organise your paints in an order that works for you. Make sure that they are all clean and ready for you to start painting. If you do not have any paper stretched, stretch a few sheets so that you do not have to think about it later.

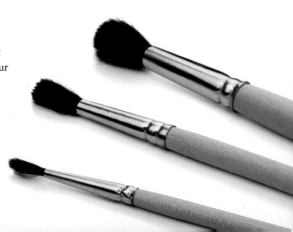

Clear your mind

Nothing clears your mind like exercise – you don't have to start a training regime, however! Instead, try a walk or a run. While you're exercising, you will take in fresh air and circulate oxygen around your body which will make you feel invigorated. As you walk or run, look around you to see the beauty everywhere. You may even stumble across something to paint.

Visit a gallery

Another great way to feel inspired is to take your inspiration from others. The best way to do this is to go to a gallery and surround yourself with beauty. If you don't have a nearby gallery, spend some time looking at art online. Many artists have their own websites where you can see their art and also find out more about the work and artist.

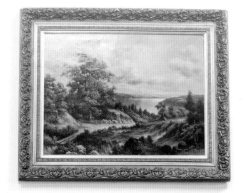

Drawing

Before you can produce successful watercolour paintings, you need to first practise drawing your subject. Drawing will train your eye to see a subject accurately so that you can convert what you see into lines or marks on your sheet of paper.

Freehand drawing

The pencil drawing required to produce watercolours doesn't need to be a masterpiece. Instead you are drawing to explore your subject so that you can paint it more accurately. Watercolour paper and paints are far more expensive than a sketchpad and pencil, so practising on the cheaper medium is good financial sense.

Seeing your subject

Drawing before you paint helps you to explore the line and form of your subject. By doing so, you will better understand the proportion and perspective of your subject. You will also be able to see how light affects your subject.

Placing your subject

Drawing also helps to achieve balance in composition. By first drawing your subject, you will see which details to include and which to omit. To achieve a balance, you need to think about where on the page you are going to place your subject. One way to decide this is to draw a few thumbnail sketches with varying compositions. It may be a good idea to draw these and then to look at them from a distance. Sometimes, stopping and taking a little break will also help you to decide which composition gives the most balanced drawing.

Seeing shapes

To start your drawing, look carefully at your subject to see what simple shapes are present. All drawings can be broken down into shapes such as circles, ovals, squares and rectangles. Draw these accurately to give your subject a basic outline. When you're happy with the outline, you can refine it to create the actual subject.

Practise makes perfect

Once you've practised drawing your subject, you will feel more confident and relaxed when you paint. If you are confident, it will show in the quality of your art.

A lesson in colour

Understanding colou

*Before we can look at how to use colour when we
paint, we need to understand a little about the science
behind light and colour and how we see colours.*

White light

The Sun is a natural light source. Children often paint the Sun's rays as yellow but in fact,
the light that we see from the Sun actually consists of different colours. We cannot usually
see these colours separately because they combine to produce what is known as 'white light'.

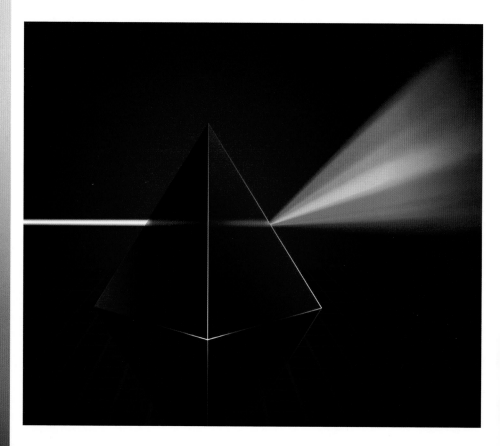

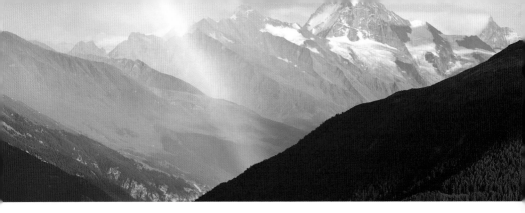

Spectrum of light

The patterns of colour in white light are known as the 'spectrum'. There are seven main bands of colour in the spectrum. They are red, orange, yellow, green, blue, indigo and violet. The most obvious example of the spectrum is when light is reflected through water droplets in Earth's atmosphere to create a rainbow.

Seeing the colour

Light travels in waves and each band in the spectrum has a different wavelength, for example, red has the longest wavelength and indigo the shortest. Different objects have different colours because they absorb and reflect different wavelengths of light. When light waves hit an object, only some of the light is reflected. For example, a red car reflects all the red wavelengths of white light but absorbs the blue, green and yellow wavelengths, so all you see is the red reflection. White objects reflect all the wavelengths, while black objects absorb all the light waves that hit them.

Is it really red?

When light bounces off an object and we see a colour, our brain interprets that colour. Everyone's brain will interpret colours in the same way, but how we actually experience the colour varies from person to person. Our experience is shaped by our culture, memories, past exposure and mental associations.

Colour palette

The choice of colours in an art shop can be overwhelming and there may be hundreds of paints to choose from. However, because paints can, and should be, mixed to achieve the colours you want, you do not need to buy them all.

Choosing colours

There is no perfect list of colours to choose for your palette. Every art book or website will list different colours, usually those preferred by the artist or author. To find your preferred colours, start with a basic few, usually around 12. You can then add to or remove the colours you don't often use. You will probably find that as your subjects change, so too will your palette. A good, basic palette to start painting with could include cadmium yellow, azo yellow, cadmium red, quinacridone red, cerulean blue and Prussian blue. Many artists will buy a single pigment black rather than mix their own from the primary colours. You don't need a white pigment – the white of your paper can be allowed to show through.

What to look for

While what colours you choose for your palette is subjective and a matter of personal preference, there are certain criteria to look for in paints. These include quality, permanence, transparency and staining.

38

Quality

When choosing your palette, it is worth buying the best paints you can afford. As we've already discussed, often the cheaper student-quality paints have weaker pigments and you will probably find that you use more of them to create the desired colour.

Permanence

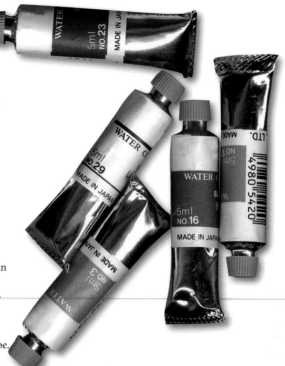

The ability of paint to withstand light and humidity without dulling or fading is called permanence or lightfastness. Just as things fade in the sunlight, so too will your painting if you use paint with a poor permanence rating. Try to buy paints that are rated 'excellent' or 'very good' by the ASTM (American Standard Test Measure). These ratings can be found on the side of the tube.

Transparency

Although you can buy opaque watercolour paints, those that are transparent are often favoured by watercolourists. Transparency is important for layering because you cannot layer an opaque colour over a transparent one.

Staining

Some watercolour paints sit on the surface of the paper, while others actually stain it. Those that sit on the surface are more forgiving if you are new to painting because you can rectify mistakes more easily when using these paints. If you're layering your paint, non-staining paints may also lift and mix with other colours.

Mixing colours

Once you have chosen your palette of colours, you can begin to mix them to create wonderful colours. In addition to mixing colours in a mixing well, there are other techniques you can use to mix colour. These include glazing and scumbling, both of which are discussed later in the book.

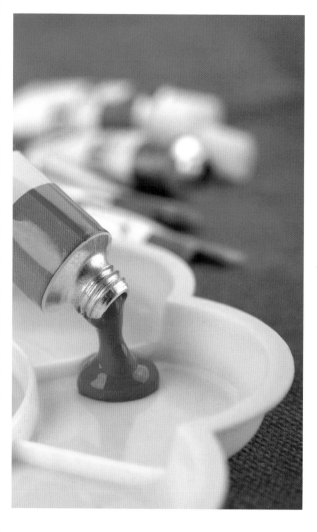

Mixing wells

To mix colours, you will need your paints, brushes, some clean water and a mixing well. It is important the mixing well doesn't have any paint residue on it. If the well is dirty, as soon as you add water to the 'old' paint, it will be usable again, and will also mix with your new colours.

Mixing the colour

Taking a clean brush, touch the bottom of your clean water container so that the bristles of your brush open up. Lift your brush out of the water and slide it against the rim of your mixing well to create a little puddle of water. How much water you use will depend of the depth of hue you are aiming for. Now, stroke your brush against the top of the pigment to pick up the colour. When you have sufficient colour, mix this with the little puddle of water. It is a good idea to test your colour before you add it to your painting.

Adding a second colour

In you are mixing two colours together, without rinsing your brush, pick up colour, add it to the little puddle of colour and mix it in. Don't worry about contaminating your paints. Once they have dried, wet them a little and use a clean piece of kitchen towel to wipe over the top of the paint. While you can mix several different colours together, if you mix too many, you will create a muddy puddle of brown. It is best to mix just two colours and never more than three.

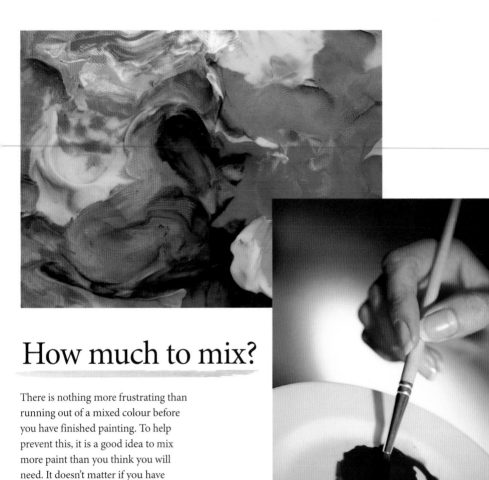

How much to mix?

There is nothing more frustrating than running out of a mixed colour before you have finished painting. To help prevent this, it is a good idea to mix more paint than you think you will need. It doesn't matter if you have paint left over – you can always rewet it and use it another time.

Harmonious colours

While complementary colours contrast enough to grab the viewer's attention, harmonious colours are, as their name suggests, used to bring peace and harmony to a painting. By choosing a harmonious colour scheme, you will bring a sense of coherence and unity to your watercolour work.

What are harmonious colours?

Harmonious colours are sometimes referred to as analogous colours. They are colours that are close together on the colour spectrum. At one end, there are blues, purples and greens and at the other end, the choice is reds, oranges, browns and yellows. Harmonious colours are often seen in nature. Think of an autumnal scene with the leaves of an oak tree, changing colour. They change from green to a variety of reds, oranges and browns.

Mixing harmonious colours

If you find mixing colours a little daunting, especially if you are new to watercolour painting, be assured that mixes of any analogous colours tend to combine successfully. You will need to experiment with your mixes on a replica piece of paper to ensure that you have achieved enough tonal variety in your mixes.

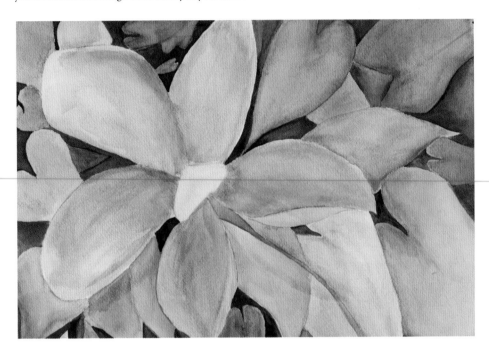

Using harmonious colours

Harmonious colours can look dull when used together and your painting can lack the vibrancy created by using complementary colours. To get the most out of harmonious colours you need to use a good variety of tone. This will ensure that while your painting looks balanced, it will also be vibrant. You should choose one colour to dominate your painting and a second colour to support the dominant colour. The third colour should be used as an accent. For example, if you look at the painting above, you can see that the artist has chosen colours from the blue end of the spectrum. The combination of blues, purples and greens has created a calming floral painting, with green as the dominant colour. Blues and violets are the supporting second colour and the yellow is the accent. By mixing different shades of green, the painting is given a sense of dynamism without losing the harmony.

45

Colour temperature

The mood and feel of your painting will be affected not only by using complementary or harmonious colours, but also by warm and cool colours. Simply put, by choosing the right colours, you can set the temperature of your painting. Colour temperature theory uses people's psychological perception of colour to enhance a viewer's interpretation of the painting.

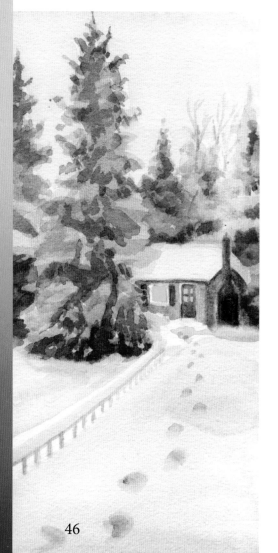

Cool colours

The colours on the blue section of the colour wheel, from violet to green are known as cool colours. The coolest colour is blue. When you think of these colours, you think of things such as snow and ice. As a result, using cool colours gives your painting a clean, refreshing feel. Cool colours also appear to recede when used in painting. For example, trees painted with a lot of cool colours will recede into the paper.

46

Warm colours

Warm colours are those on the red section of the colour wheel. Warm colours range from purple to yellow. Red-orange is the warmest colour on the wheel. Using warm colours heightens emotions and instantly grabs the viewer's attention. When using these colours, elements of your painting will appear to advance out of the paper.

Positioning colours

While colour temperature holds true most of the time, it is a mistake to assume that blues will always give your work a cool feel, or that using reds creates a warm feel. In fact, by positioning your colours carefully, you can also set the temperature. For example, purple next to red will seem warm, but purple next to orange will seem cooler.

Mixing colours

There are also gradations of colour temperature within the warm and cool colour groups. You can alter the temperature of a colour so that it is cooler or warmer by adding colour from the opposite group. For example, you can add blue to red hue to make it cooler. Similarly, adding red to blue will create warm shades of violet.

Washes

The first step in painting with watercolour is to be able to lay a wash. Washes are the base colour of your painting, to which other colours are added. There are two types of wash: flat and graduated.

Flat washes

A flat wash is one in which the colour is uniform across the paper. Before you start to lay your wash, here are some important tips to ensure it is a success:

• Make sure you mix enough paint to complete your wash – if you have to mix more paint halfway through, you are unlikely to match your initial wash.

• Always make your wash slightly stronger than you think it needs to be. When wet, the colour may look too saturated, but as the paint dries, it will fade.

• Put your paint next to your paper on the same side as your starting point – you don't want to lean across your painting and drip onto it.

• Test your colour on a separate piece of the same type of paper before you lay it.

• Work quickly because otherwise the paint will dry and your wash will be uneven.

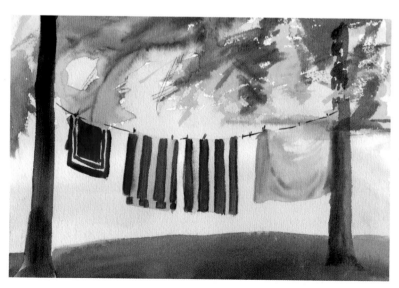

Laying a flat wash

To lay a flat wash you will need a flat or chisel-ended brush, your paint mixed to the desired colour and some stretched paper. To start with, place your paper at a 30 degree angle. This will ensure that your brush strokes flow into each other and create a smoother, more even finish. Working top to bottom will also help with this.

Step 1: Load your brush with plenty of paint. Starting at the top edge of the piece of paper, put down a broad horizontal stroke, from one side of your paper to the other. do not lift your brush until you've gone all the way across the sheet of paper.

Step 2: Once you've done one brush stroke, add some more paint to your brush. Repeat the process of making a horizontal stroke but make sure you pick up the paint from the bottom of the first stroke. Be careful not to paint over the bottom of the first stroke, otherwise your wash will be uneven. Continue with your horizontal strokes until you reach the end of the paper.

Step 3: Once you've reached the end, use a clean cloth to mop up the excess paint from the brush and use the tip to mop up the excess paint from the bottom of the last stroke. Leave your paper at an angle until the wash is completely dry, otherwise some of the wet paint will flow back up and your wash will dry unevenly.

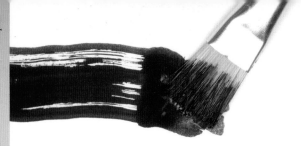

Laying a graduated wash

A graduated wash is one in which the colour fades either towards the top or the bottom of your painting. To lay a wash that goes from dark to light, start by mixing your paint. Create the first puddle using a darker hue for your wash. Then, in a clean part of your mixing well or palette, mix another puddle that is roughly half the intensity of the original colour that you mixed. Again, it is easier to work top to bottom.

Step 1: Charge your brush with paint from the darker mix, and starting in the upper left corner, paint a horizontal stroke without lifting your brush until you reach the upper right corner.

Step 2: Dab your brush on a sponge or paper towel and refill your brush, this time with the lighter mixture. Start your second stroke overlapping the bottom of the previous stroke, just as you would when laying a flat wash.

Step 3: Rinse your brush clean but do not dry it. Instead, dip the wet brush into the lighter mixture. Paint the next horizontal line. You should be able to see that the strokes are becoming lighter as you paint.

Step 4: Rinse your brush well and using clear water start your last overlapping stroke. Then, squeeze the water out of your brush and pick up the bead of paint at the bottom of the wash.

If, when laying your wash, your stroke breaks up or doesn't flow evenly, charge your brush and redo the stroke immediately. If you wait, the paint will dry, leaving uneven, messy strokes.

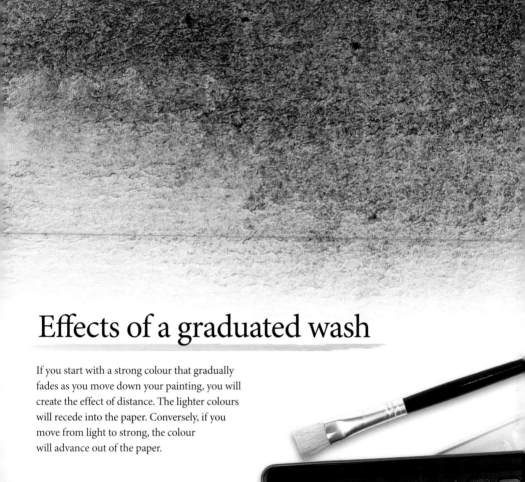

Effects of a graduated wash

If you start with a strong colour that gradually
fades as you move down your painting, you will
create the effect of distance. The lighter colours
will recede into the paper. Conversely, if you
move from light to strong, the colour
will advance out of the paper.

Light to dark

To create a graduated wash from light to dark,
you will use a similar process to that used on
page 52. However, you will need to start with
the lightest colour and work up to the darkest.
Don't be tempted to start at the bottom of the
paper and work your way up. Always start top to
bottom and left to right.

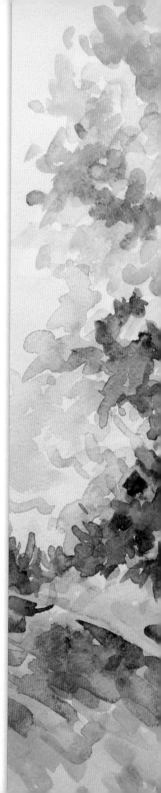

Wet into wet

'Wet into wet', 'wet on wet' or 'wet in wet' are three names used for the same technique. As its names suggest, this is painting onto a wet surface so that the paint flows over the paper.

Using wet into wet

The results of wet into wet are unpredictable and as a result, this technique can frustrate those painters who like to control their work. It also requires a fast way of working, because the work has to be finished before the first layers have dried. You need to work quickly and decisively if you choose to paint on wet paper. If you use only wet into wet to complete your painting, you will create atmosphere and a softer, diffused look. It is especially useful in painting weather, capturing movement and diffusing shapes.

Choosing your paper

Choosing the right type of paper is essential for wet into wet painting. A heavier paper is preferred because it will not crinkle as moisture is added, unlike lighter-weight paper. While hot-pressed paper will allow colours to float over the surface of the paper, cold-pressed and rougher paper will absorb more colour. To find the best paper for your needs, take a small sample of different papers and try a test patch to see which paper gives the desired effect.

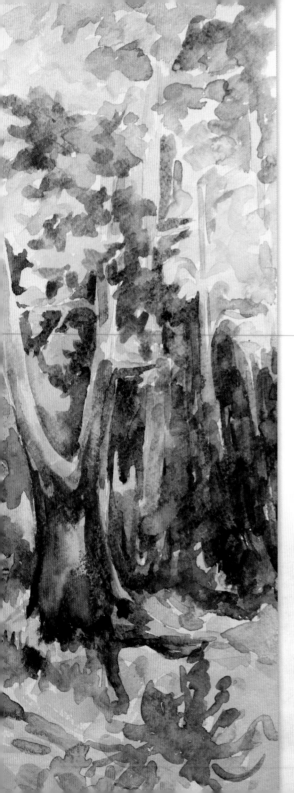

How to do it

Once you have chosen your paper, you will need to stretch the paper to prevent it from crinkling. To paint wet into wet, you need to have access to clean water. Because of this, wet into wet is not best suited to watercolour painting outdoors.

Step 1: Wet your paper with a damp sponge or wide brush and clean water. Your paper should be completely saturated. You also need to wet the paper evenly, otherwise your wash will be uneven, too.

Step 2: Mix your colours and apply a flat wash of a single colour. Use the largest brush available for this first wash so that you can work as quickly as possible.

Step 3: While the surface is still wet, add a second and third colour. If you feel that you want more blending, tilt and move your paper to control the flow of colour on the surface. Conversely, if you feel they are 'out of control' simply mop them with some kitchen paper.

Patience is a virtue

It takes a great deal of patience to paint using wet on dry because each layer of paint must be completely dry before you can add the next one. One way to dry a painting is to use a hair dryer. This may sound like a simple task but it can be tricky because you need to dry the paper evenly. If the paper dries unevenly, it may buckle. Never turn the hair dryer up high, even if you are desperate to continue working on your painting. By using a high setting, you could turn the water into steam or you could even scorch your paper. Keep the dryer on a low setting and hold it a good distance away from your painting – about 25 centimetres (10 inches) away. If you're working on unstretched paper, use the hair dryer on the back of the sheet as well as the front. If you really cannot wait for a layer to dry, rather than mess up your painting, start a second painting and take it in turns to work on each one.

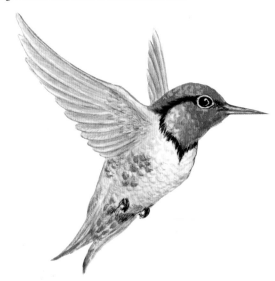

Is it dry?

Because your paper needs to be completely dry before you can paint the next layer, you'll need to test it to see if it is dry. Obviously, if it's just a sheet of paper that you've stretched, you can just touch it. However, if you've already painted on it and you touch it, oils from your fingers could transfer onto the paper, ruining your painting. One way to tell is to hover your hand just above the painting. If the painting feels cool, it is probably still damp.

58

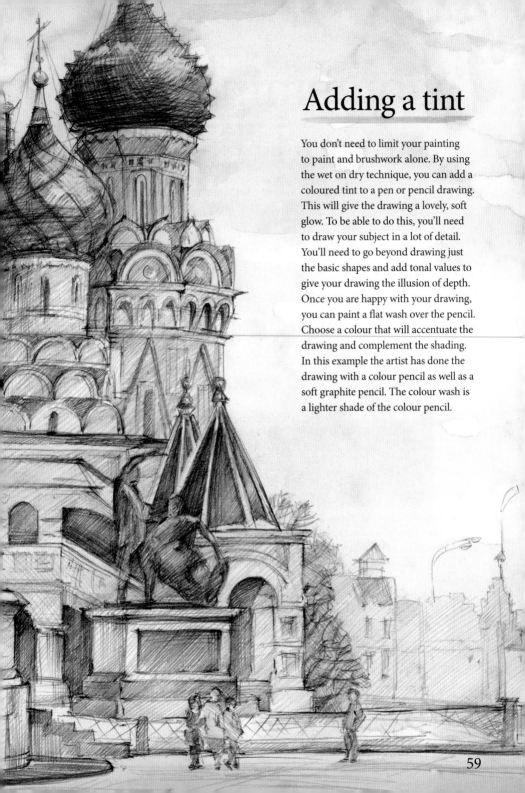

Adding a tint

You don't need to limit your painting to paint and brushwork alone. By using the wet on dry technique, you can add a coloured tint to a pen or pencil drawing. This will give the drawing a lovely, soft glow. To be able to do this, you'll need to draw your subject in a lot of detail. You'll need to go beyond drawing just the basic shapes and add tonal values to give your drawing the illusion of depth. Once you are happy with your drawing, you can paint a flat wash over the pencil. Choose a colour that will accentuate the drawing and complement the shading. In this example the artist has done the drawing with a colour pencil as well as a soft graphite pencil. The colour wash is a lighter shade of the colour pencil.

59

Dry brush

Dry brush is another watercolour technique used in combination with other techniques. In this technique, an opaque colour is put over a darker colour in broken patches by rolling the brush. The darker colour shows through the lighter one.

Creating textures

The dry brush technique is very effective in creating texture with watercolours, something that can be difficult to achieve. It can be used to give the look and 'feel' of rough tree bark, froth on a wave or a gritty road surface. It can also be used to create the texture of hair in portraiture.

Adding focus

Dry brush produces very crisp, hard-edged marks. Because these marks are so distinct, they can really enhance a focal point if they are used around it. However, if used incorrectly, they may detract from your intended focal point. For example if you use dry brush in the background of a landscape painting, the focus will shift to the background of your painting, creating a feeling of imbalance.

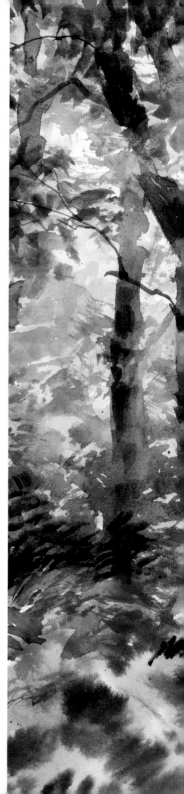

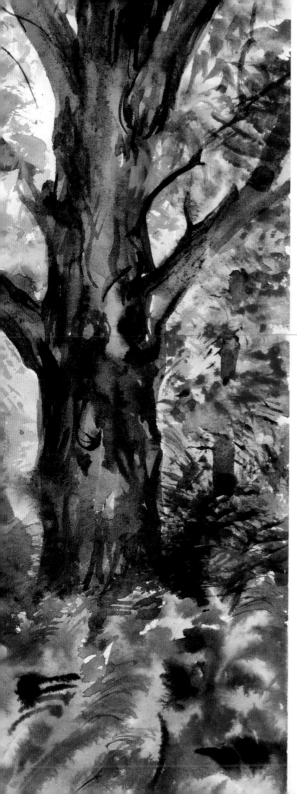

The final result

There are a number of factors that will affect the final result of your dry brush strokes. These are:

• Part of brush used: if you are painting with a round brush, you can use the side of the brush and allow the point to touch the paper. You can also just use the bulb part of the brush without the point touching the paper. Each of these will create a different effect.

• Paper type: dry brush can be used on any watercolour paper type but it is much easier to create use a dry brush stroke on rough, textured paper.

• Speed of brush movement: the speed of your movement will need to be determined by the paper you are using. If you are using smooth paper you need to move the brush very fast to create this type of stroke.

• Dryness of paper: this kind of stroke can be produced only on dry or slightly damp paper. It is more difficult to create the right effect on damp paper.

• Paint: the amount of paint on your brush and its consistency is important. The wetter your brush, the faster you will need to work.

Blending

Blending, or charging, as it is sometimes called, is a watercolour technique where colour is mixed on paper rather than in a mixing well or palette. Blending allows for a smooth transition between colours. It can also create the illusion of shadow.

How to blend two colours

Tilt your paper and then fully load your brush with the first colour. Establish your watercolor bead and paint the top of the area you wish to paint. Rinse out your brush and blot it well. Now, fully load your watercolour brush with the second colour. Lightly touch the bead with the tip of your brush and continue to release more colour. Make a light, bouncing motion with your brush as you work your way across to the other side of the bead. Your new watercolour bead will now be a blend of the two colours. Paint with this new watercolour bead until it decreases in size. Rinse out your brush and then load it with the second colour again. Charge it into the mixed colour bead and finish painting the area.

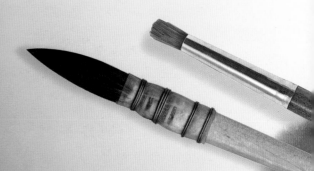

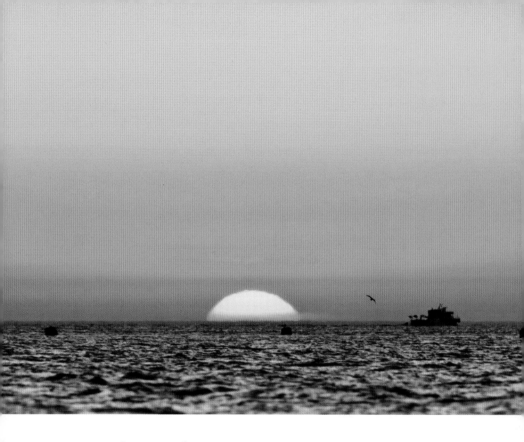

Reverse the colours

Once you are comfortable blending the colours, you can try reversing the colours midway. So your paper will start with the first colour, which will be blended into the second colour. Then this will be blended again with the first colour. This takes a bit of practice, but the end result will be worth it.

Charging small details

You can use charging on areas as small as a flower petal. To do this, load your brush with the first colour, then blot it lightly on a tissue. Paint as far as you would like your first watercolour to go, touching your brush lightly to the paper with each stroke. Rinse your brush and blot it very well before loading your brush with the second colour. Blot your brush lightly on the tissue. With light, overlapping brush strokes, charge the two watercolors together. Rinse your brush and blot well. You'll need to work quickly because the charge won't work if the paint dries.

Brushwork

Watercolour painting is unforgiving and it is not always possible to correct or amend bad brushwork, so you need to think carefully about your brushwork before you begin to paint.

The right brush

There are several factors that influence brushwork:

• Types of brush: as you know, brushes come in a multitude of different shapes, sizes and bristle type. Each of these brushes has can produce a wealth of strokes. While many artists favour a couple of brushes, it is a good idea to experiment and practise with all the brushes in your box. Try to observe the many different strokes you can create with each brush.

• Area of brush: the surface area of your brush that you use can create different strokes – for example, using more of your brush will create a different stroke from the one you'll produce if you use a smaller area of it.

• Pressure applied: how much pressure you apply to the brush when making your strokes will also affect your brushwork. The more pressure applied, the fatter the line.

• Wetness of your brush: the wetness of your brush will completely change not just the colour of your strokes, but also the lines they create.

• Speed of marks: the faster you work, the less time your paint has to dry.

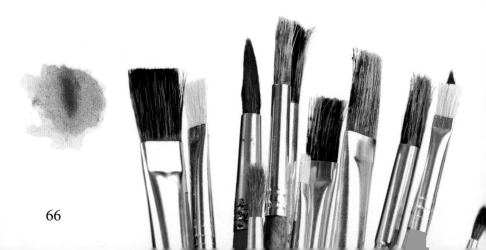

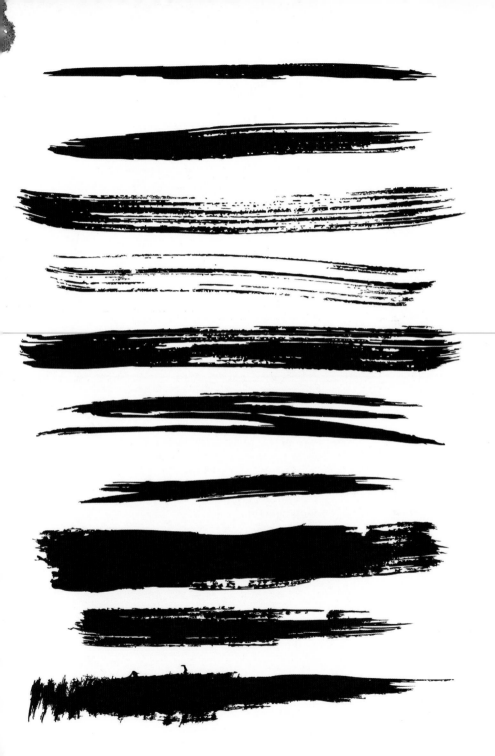

Different kinds of stroke

Artists use many different kinds of brush stroke and each has a different effect on the mark on your paper. It is a good idea to practise different strokes to build up your painting confidence.

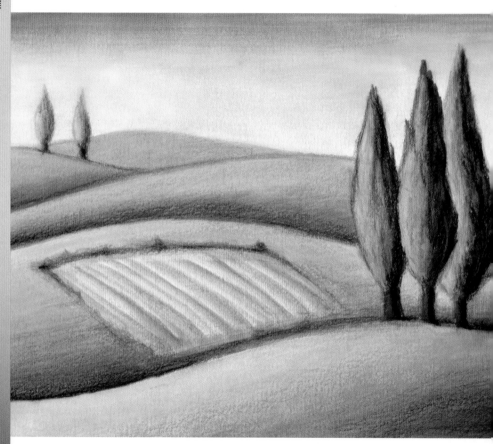

Smooth strokes

These strokes work best to portray solid surfaces that have straight lines. They are created using a round brush. The brush is gently swept over the surface of your paper to create an even line.

Flowing strokes

Flowing strokes can be used to paint water, hills and any objects with long, gentle lines.

68

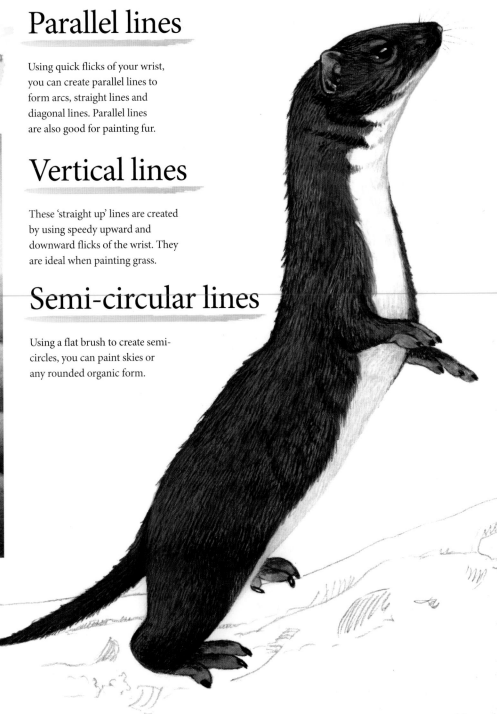

Parallel lines

Using quick flicks of your wrist, you can create parallel lines to form arcs, straight lines and diagonal lines. Parallel lines are also good for painting fur.

Vertical lines

These 'straight up' lines are created by using speedy upward and downward flicks of the wrist. They are ideal when painting grass.

Semi-circular lines

Using a flat brush to create semi-circles, you can paint skies or any rounded organic form.

69

Drybrush and Scumbling

We know that the relationship between water and paint is crucial to the final outcome of your watercolour paintings. However, as a watercolourist, you don't always have to wet your brush when painting.

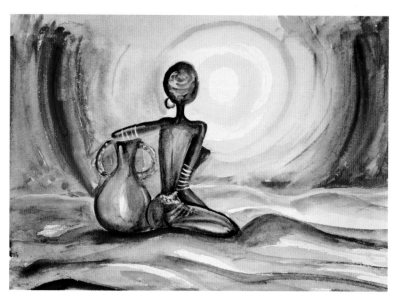

Drybrush

Drybrush is a technique that offers the artist precision and control. As its name suggests, drybrush involves picking up undiluted paint with an almost dry, small brush. Because this technique works best with as little water as possible, tube paint is often preferred. Be careful not to overcharge the paintbrush with paint. The tip should have enough paint to transfer to the paper with slight pressure and without dissolving the underlying wash. The paint is then applied to the paper using a series of hatching and cross-hatching lines. Hatching lines are parallel lines, close together, used to create texture. Cross-hatching lines are perpendicular lines over hatching lines, creating a cross-effect. The goal is to build up or mix the paint colours with short, precise touches. Often it is impossible to distinguish a good drybrush watercolour from a colour photograph or oil painting. To enhance this realistic effect, drybrush paintings can be lacquered.

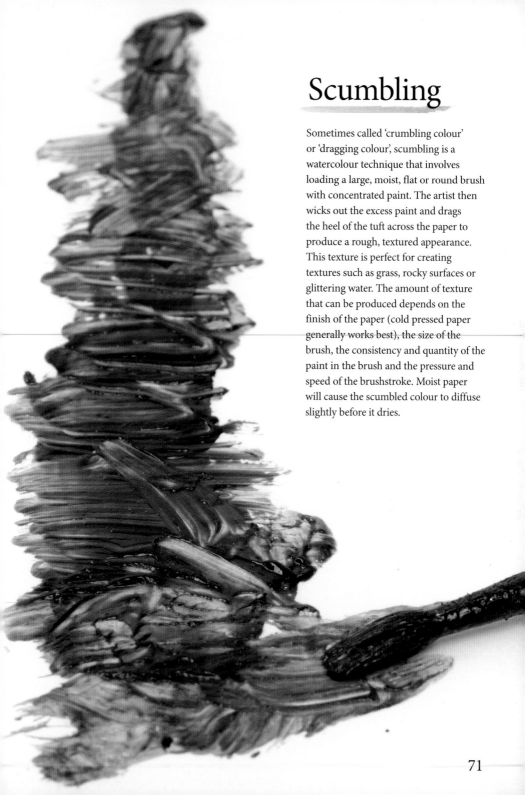

Scumbling

Sometimes called 'crumbling colour' or 'dragging colour', scumbling is a watercolour technique that involves loading a large, moist, flat or round brush with concentrated paint. The artist then wicks out the excess paint and drags the heel of the tuft across the paper to produce a rough, textured appearance. This texture is perfect for creating textures such as grass, rocky surfaces or glittering water. The amount of texture that can be produced depends on the finish of the paper (cold pressed paper generally works best), the size of the brush, the consistency and quantity of the paint in the brush and the pressure and speed of the brushstroke. Moist paper will cause the scumbled colour to diffuse slightly before it dries.

Masking

You can leave areas of your paper unpainted while you paint around them. However, this is not only difficult to do, but also very time consuming. For example, if you wanted a wash behind a vase of flowers, you would need to ensure you applied the wash around the outline of the flowers. Rather than attempt this difficult feat, artists use masking.

What is masking?

Masking is a technique used to cover specific areas of paper so that they are not covered in paint. The most popular ways to mask out areas of your paper are by using permanent masking medium, masking tape or masking fluid. The medium best suited to your work will depend largely on your expertise and the desired effect. Each one will leave different shapes on the paper.

Permanent masking medium

Permanent masking medium is recommended for fine detail and to create specific effects. It can be applied directly to white paper, to dried washes on the paper or mixed with watercolours first, before you paint. If you mix the medium to a paint and then apply a wash, you will be able to work on the wash as usual until the wash dries. Once dry, the area becomes isolated and you cannot add further washes. While it is a great advantage for an experienced artist, if you are not especially confident, you'll need to carefully plan your painting to make sure you use the masking medium to the best effect. If you use a permanent masking medium, your brushes should be washed in warm water and soap before using other colours.

Masking tape

This non-adhesive tape comes in a variety of widths and is excellent if you want to mask out straight lines or structured geometric shapes. Cut off pieces of tape and create your desired shapes. If the edges are too harsh, you could tear the tape to create a softer line. Press the tape down firmly to ensure that it is fixed firmly to the paper so that watercolour paint does not seep underneath. When your paint is dry, carefully remove the tape, taking care not to damage the paper underneath.

Masking fluid

Masking fluid is a special fluid that is applied like paint, but dries to a rubbery film that can be easily removed. Masking fluid can be used to create any shape of any size or simply to preserve areas of the paper. To apply masking fluid, use a pen, cocktail stick or even an old brush. You will need to wash the brush in soapy water after use, however, or it will be forever ruined. Paint or dab on the masking fluid and when it is dry, paint over it. When you're ready to peel it off, do so with a clean hand or a clean eraser. Masking fluid works best on smooth paper because it can damage the texture of the paper. It must always be applied to dry paper. The golden rule for working with masking fluid is to plan your painting. You need to know exactly where things are going before you start working with it. If you're using masking fluid, do not use it straight from the jar or container. Rather, empty a small amount out so that you can dilute it if necessary.

Lifting out

Once you've put a stroke on your paper, it can be tricky to remove it, or lift it out. However, there are some simple techniques you can use to do this.

Blotting with tissue

To lift paint out of the paper, take a clean, wet sponge and wet the affected area. When the paper is wet, absorb the colour with a clean tissue or small piece of kitchen towel. If this doesn't work, you may need to leave the water to soak into the paper, then try to remove it once more.

Brushes

If the paint is quite wet, you can use a dry watercolour brush to mop up the colour. Harsher oil or acrylic brushes may also work, but you need to be careful not to damage the paper when you scrub.

Sharp objects

You can also use sharp tools such as penknives and razor blades to scrape out the paint. However, take care because these objects may damage the paper or even cause an injury.

A tip or two

Like any new hobby, you will encounter some obstacles along the way to painting your masterpiece. Hopefully, the following tips and hints will help to quell any anxiety as you paint and improve the quality of your work.

Materials

• Keep all your scraps of paper and write what each one is on the reverse. You can use these scraps for testing colours and techniques.

• Wash brushes in warm soapy water until there are no traces of colour left on the bristles. Dry the brush and reshape the bristles.

• To scrape out highlights, for example veins on leaves, use a sharp craft knife.

Colour

• Always test your colours on the type of paper you are painting on. This will ensure that you will accurately see how the paint will sit on the paper.

• Banish grey and black from your colour palette. These colours will dull your painting. Instead, try mixing them from the other colours on your palette for a more subtle result.

• Paint or print out a colour wheel that you can pin up near to where you work. This will help you instantly recognise the colours that work well together.

• After you've washed your brush, dab it onto a clean dry cloth. This will prevent you from adding more water to your paint than necessary.

• If you've loaded your brush but feel there's too much paint on it, use a clean cloth to soak up the excess paint from the ferrule end of it.

Seeing your subject

• If you try compositions that break the rules, you're sure to have many disasters. However, for all your disasters, you may have one success, and that success will be truly amazing.

• If you're unsure about what colour to paint your shadows, ask yourself what primary colour your subject resembles. Then use your colour wheel to work out what the complementary colour is. This is the colour to use for your shadow.

• If you're working from a photograph, remember that the eye sees the subtle tones in shadows, but a camera doesn't. Print the photograph twice, keep one copy as your reference and annotate the other with notes on the colours you see.

• If you're painting a still life using natural light, you will need to paint at the same time each day. This will ensure your subject stays the same.

Techniques

• Make your washes stronger than you think they need to be. Watercolours pale as they dry, so it's easy to underestimate how strong your colour will be. Stronger when wet is better when dry!

• Because the white in your paintings is usually the white of the paper left unpainted, it's best to work from light to dark.

• Wet onto wet can be alarming at first because you cannot anticipate how the paint will run. Keep a clean, but crumpled, piece of tissue to hand. If the paint starts to run on your paper, a few strategic dabs will solve the problem.

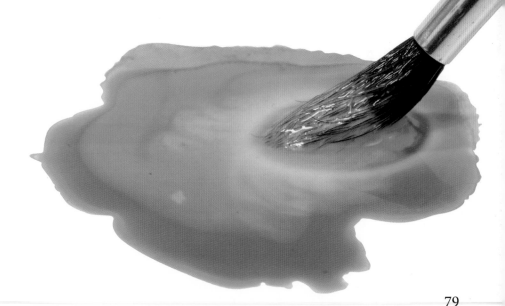

Landscapes

Scenes of nature that feature mountains, forests, gardens, lakes and other water scenes are called landscapes. Today, landscapes are very popular and most artists will have attempted a landscape scene at some point. However, landscapes haven't always been highly valued. In the past, painting of natural scenes was considered lower in status than other subject matter, such as portraiture.

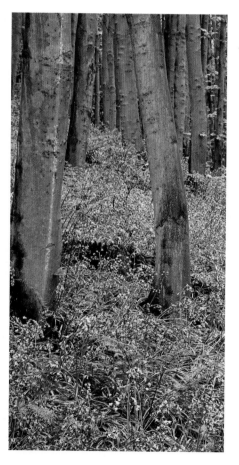

Choosing a subject

The first step to painting a landscape scene is to find something to paint! To do this, you'll need to choose a viewpoint. Where you stand will determine what you see and the angle at which you see it. Take your time – you should spend as much time observing the landscape as you do drawing it.

To help find the best view, you can use a viewfinder. Try to find something that stands out or has interesting colour combinations, for example a blue sky against a tree with autumnal leaves. While you might be tempted to put everything you see on your paper, you don't have to. Rather, choose the strongest elements, those that give the landscape its characteristic look, and paint them.

While you can control the light of a still life painting, controlling natural light can be difficult. The light will change depending on the time of day and the season. To combat these changes, you will need to view your scene at the same time each day. This isn't entirely convenient because you'll also have to paint quickly to avoid the light changing as time passes. Instead, you can take a photograph of the scene. Make a copy of the photograph and annotate it with notes about the light.

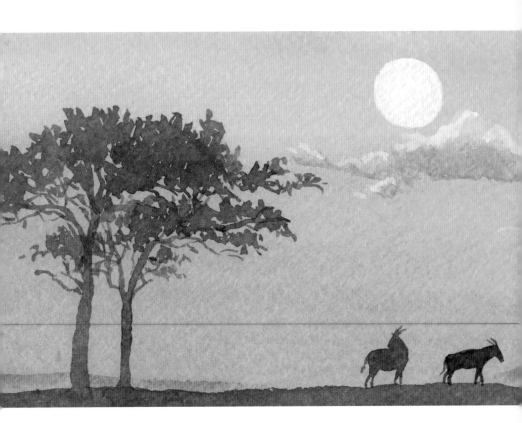

Getting the composition right

There is no rule that says you have to paint the landscape exactly as you see it. You can rearrange the elements to suit your composition. It usually works best if your painting has more detail in the foreground and less detail in the background. However, you will need to play around with different compositions to find what works best for you. To work out the best composition, do several different thumbnail sketches. If you feel that there are several compositions that 'work', you can paint them all, creating a series of landscapes. If you are doing just one painting, your thumbnails should help you to decide where to draw your horizon line.

Waterscapes

A waterscape is a representation of a body of water. It can include a deep, almost black ocean, a raging river and a gently meandering stream. The difficulty in painting water is that it is very rarely still, and to capture this movement can be difficult.

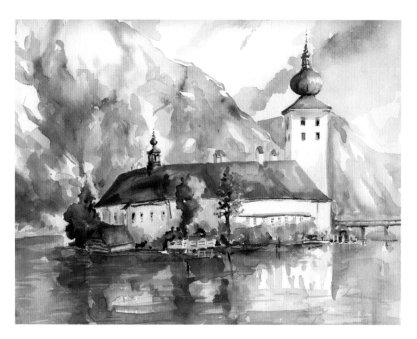

Shallow or deep

To be able to paint the different bodies of water successfully, you need to understand that because some water is shallow and other water is deep, it will have different characteristics:

• Shallow water: ripples are created in shallow water as the water moves over rocks and other debris. Shallow water is lighter in colour and the ripples combine the reflected colours. The ripples create bright highlights.

• Deep water: calmer, deeper water ebbs and flows more slowly. The calmer the water, the stronger the reflections of the surroundings and of the sky.

86

Choosing and composing your subject

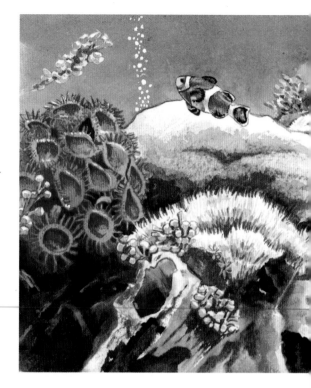

When looking for a waterscape subject to paint, you will need to observe the water very carefully. Note down what you actually see, not what you expect to see, especially with regard to the reflections in the water. The surrounding landscape or objects will be of particular importance because they are likely to be reflected in the water. Try to find water with interesting reflections. As you know, the deeper the water, the stronger the reflections. Look at the depth of the water and how this affects the clarity.

It is tempting to look only above the surface of the water to find a subject, but sometimes underneath the water, there is a lot happening that would make for an interesting painting. The shallower the water, the clearer it usually is and so the more you can see. As with all watercolour paintings, you can always do some thumbnail sketches to find the composition that works best for you.

Brushes and brushwork

Depending on the characteristics of the water in your subject, you will need different brushes. The hardness of the bristles will create different effects. Softer bristles will create a more gentle flow of water, while harder bristles will be needed for more textured water. For shallow water, use a thin brush and move your whole arm to create side-to-side strokes using quick brushwork. To paint deeper water, use a broader brush and slower strokes. Long and continuous brushstrokes give the water a smoother finish.

Portraits

You need only visit a portrait gallery to see that people have been 'sitting' for portraits for centuries. In years gone by, paying someone to paint your likeness was a sign of wealth and power. While professionals did these paintings, for the beginner watercolourist, portrait painting can be daunting and difficult.

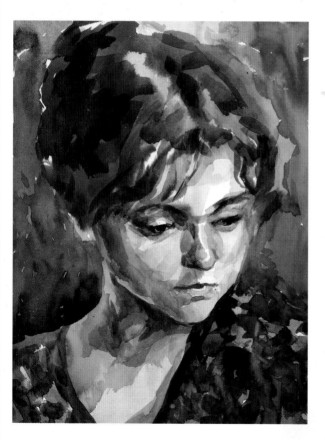

Painting a likeness

As an artist, it is your job to capture a likeness of a person and this means capturing more than just their outer appearance: you need to capture his or her inner person, too. This sounds scary in itself, but if you want to be a successful portrait painter, you need to see the person you're painting, the sitter, as any other three dimensional subject.

Proportion

The first step in capturing this likeness is to understand the proportions that make up a face and to sketch the basic shapes of the face. By following these simple rules, your portrait will be in proportion and your painting will have a balanced feel:

• A person's eyes are always half way up his or her head.

• The eyebrow is above the half-way point of the head on a person with a normal, not receding, hairline. On young children, the head is larger and the child's features are lower down.

• The distance from the hairline to the eyebrow, the eyebrow to the underside of the nose, and from the underside of the nose to the chin are almost exactly the same. This splits the face into thirds.

• The tops of ears are usually in line with the eyebrow and the lobe with the bottom of the nose. However, as people age, their ears grow larger and their lobes hang lower.

• If your sitter is looking straight, the corners of his or her mouth line up with the pupils.

• There is exactly room for a third eye between the eyes.

• The underside of the bottom lip usually falls halfway between the underside of the nose and the chin.

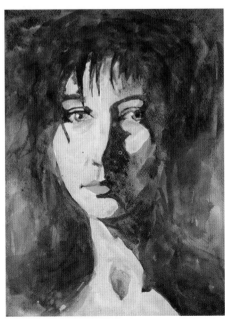

What happens if you don't want to paint your sitter straight on and you want to paint a three-quarter profile? In that case, these proportions still work, but you will see a quarter of the width of the mouth. The corner of the eye furthest from you will now be hidden by the bridge of the nose, but its centre should still line up with the corner of the mouth. The angle will also mean that the iris will become more elliptical.

Tone

The next step in accurate portraiture is to understand how tone, how light or dark a colour is, affects your painting. While at a first glance it may look like your sitter's skin is all one colour, if you look carefully, you'll see that in some places, even on those with fairer skin, there are some quite dark tones and the skin is far from uniform in colour. If you get the dark tones right from the beginning, the lighter and mid tones will be easier. It is also worth noting that even the lighter tones will be affected by shadow. Look carefully at the shape of the shadow under the bottom lip – if you don't get it right, the mouth will not be accurate.

Adding colour

The next step is to mix and add colour. As with any subject, mix more paint than you think you will need – you don't want to run out midway through your painting. You'll need to play around with different skin tones to get the right one, but remember, babies' skin is lighter than adults'. Different artists will recommend different colours for the skin, but you could try mixing magenta, viridian and burnt sienna for Caucasian skin, making it lighter and darker as you need to. For example often the lower third of the face is darker and the top third is the lightest. Pay careful attention to colour temperature, too. The centre third of the face is also the warmest. As the face recedes towards the ears, the forehead and neck are often cooler. This is what causes noses to stand out from the rest of the face. If you can strike a balance between the warm and cool colours, your portrait will be more pleasing to look at and your likeness more believable.

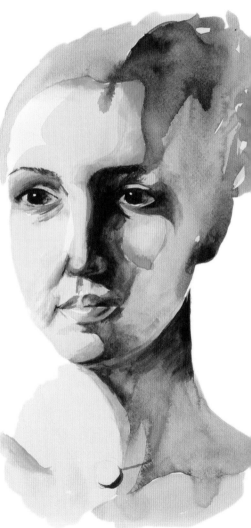

Creating a focal point

As with any subject, the viewer's eye will be drawn to the focal point, which is the crispest edge in the painting. In portraiture, the focal point is usually where there is the greatest contrast, for example dark hair next to a cheek. Soften some edges and leave some hard to lead your viewer around the painting.

Choosing a background

The background is just that, a background. It should not detract from the portrait. This will happen if the background is too busy or if there are crisp edges to it. It should also blend in with the portrait so that it doesn't look like it is superimposed on a background.

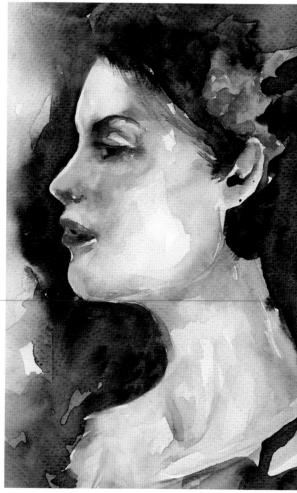

Seeing the colours

A black animal is rarely black and a white animal rarely white. There are many colours that make up the black or white of an animal. To make sure you get these right, spend time observing the animal and noting the colours that you actually see. This will prove invaluable when it comes to mixing your paints. You'll be able to mix your own black paint, rather than use black from a tube or pan, capturing the subtle shades in it.

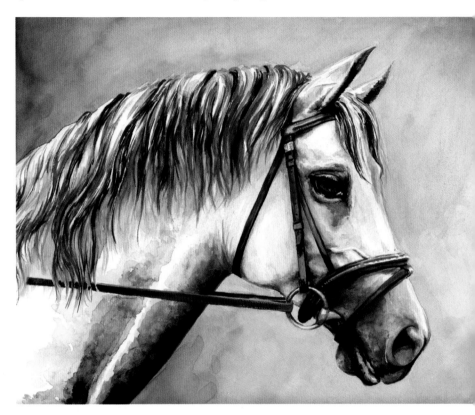

Drawing

One of the most important steps in painting your animal is to draw it first. Drawing the animal helps to get the proportions right and it also gives you a chance to check that you are happy with the composition of your painting. If you are drawing from a photograph, you can use a pair of dividers to get the proportions more precise. Work out what the ratio of your photograph to paper is. Measure the part of the animal you are drawing with the dividers and use the ratio to multiply it to give you the measurement for your drawing. To draw the animal, look for the basic shapes. Every subject can be broken down in to basic geometric shapes. Draw these basic shapes and then add the lines to complete the outline of your animal.

Eyes first

While some artists will prefer to paint in a background first, others will insist on starting with the main focal point, which is the animal. Depending on your preference, when you come to paint the animal, paint its eyes first. The eyes are crucial to the painting as they capture the character of the animal, so it is important to get them right and to be happy with them, before you get carried away with the other elements of the painting. If you do the eyes first, before your background, if you make mistakes, you haven't lost hours of painting time. Consider these things when painting the eyes:

• The eye is an orb shaped by light and shade. Try to see where the light is reflected and how the eye is shaped.

• Eyes need a highlight to give them life. Even if you can't see one, include one! The best way to do this is to leave the paper white. You can use masking fluid if you're worried about painting over the paper reserved for the highlight.

• Eyes are wet and shiny. You can capture this by adding strong tones.

• Paint the eye that you see in the reference, not the one you think you see.

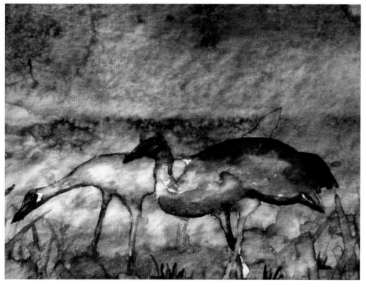

Adding your colour

Once you've painted the eyes, you can move onto the rest of the animal. When painting animals, painting from dark to light is often easiest because the dark tones are what give the animal its bone structure. Once you have the bone structure, you can add the rest of the detail.

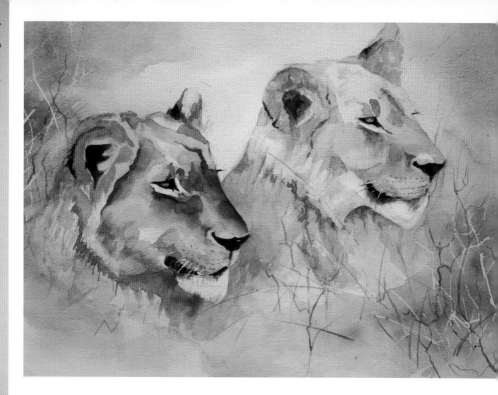

Painting fur

Painting fur gives your painting texture but it can be quite
tricky to master. You could always practise on a different piece
of the same type of paper before you tackle the final painting. If
you look carefully at the animal's fur, you'll see that much like
human hair, it's not uniform in colour. There are darker and
lighter strands, even in white fur. You will also see that there's
space between the strands to give the fur its body. To start
painting the fur, look at the colours and choose or mix your
palette accordingly. Start with the lightest colour for a wash.
When this has dried, choose the next darkest colour in your
palette to start with the fur. With light, horizontal strokes, start
painting the area – use longer strokes for longer fur. Always
paint in same direction in which the fur grows. With a slightly
darker colour, paint similar size and length brushstrokes next
to and overlapping the first strokes. The first strokes don't need
to be dry to do this. Then, mixing your darkest colour and
some black, paint in more fur between the existing colours.
The last strands of fur to add should be plain black (but this
will depend on your animal).

Painting feathers

To successfully paint a bird, you don't always have to paint each and every feather in perfect detail. Instead, you want to give the illusion of feathers. Wet into wet watercolour is the perfect technique to create the soft, fluffy feel of feathers. However, watercolour can also be a difficult medium to use to get the contrast of light feathers next to darker ones. To paint feathers, paint the lightest colours wet on dry with a sharp brush. Then using darker tones, add the darker feathers using small brushstrokes. Always move your brush in the direction of the veins of your feathers. You don't need the edges to be perfectly even. If they're uneven, they'll look softer to touch but still in focus.

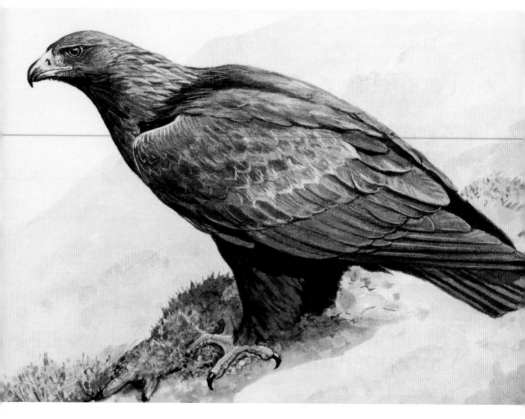

Painting scales

When painting the scales of a fish, unless you are striving to paint a realistic, detailed fish, you don't need to paint each and every scale. But you do need to give the impression of scales so that a fish looks like a fish! Before you start, pay careful attention to the shape of the scales, how do they overlay each other and how do they change size? To paint the scales, use lighter and darker tones to create shadows and highlights that will give the illusion of scales.

Light and dark

Because buildings are outside and there is either a natural light source, such as the Sun, or an artificial light source such as a street lamp, part of the building will be in shadow and part will be in the light. If you are painting by observation, try to paint the building at the same time each day to ensure that you see the same lighting effects.

Angles

You can get the angles of your building accurate by using the face of an analogue clock. Use twelve o' clock as the horizontal line and work out the angles by finding them on the clock. For example, the wall of your building will be straight at twelve o' clock, while the pitch of the roof will be at twenty-past, so in line with the five on the clock. The gradient of any slope on the building can be measured in this way. You may want to distort some of the straight edges when it comes to painting these lines because too many perfectly straight edges can be distracting.

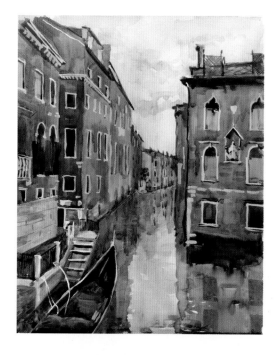

102

Sketching

To render the building accurately, you can also use a photograph to create a grid reference. To create the reference, photocopy a print of the building. This is better if it is black and white because you can use it later to see the values. Using the photocopy, draw a grid on the photocopy. Count how many lines you have across and down so that you can match this on your paper. On your watercolour paper, as lightly as possible use the grid reference to draw your building. Draw whatever is a block on the photo grid onto the corresponding block on the paper grid. Soon you will have your building in perfect proportion.

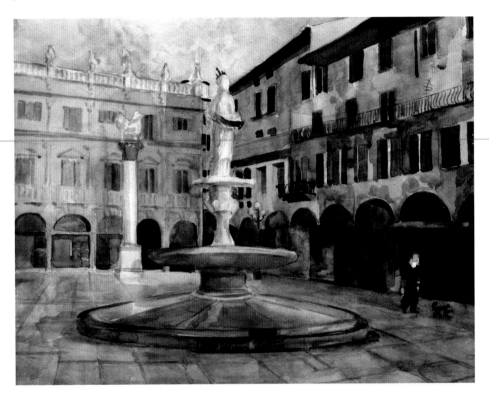

Painting

Once you've drawn your building, you can begin to paint. Sometimes, it is easier to paint the figures first. You don't need to include much detail in their faces. Using a dry brushstroke for their legs can help to create the illusion of movement. Fill in the colour from dark to light, leaving the white of the paper to add luminosity. Remember to add the shadows that the figures will create as well as any reflections in the windows.

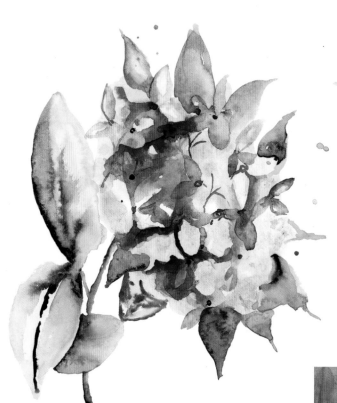

Drawing

By now you will know the importance of drawing your subject before you begin to paint. The simple shapes that you draw will gain body as you fill in the lines. If your still life has bottles, cups or vases in it, you will need to practise drawing ellipses before you tackle your painting. Remember if your vase is filled with water, you'll need to draw the ellipse of the water line too.

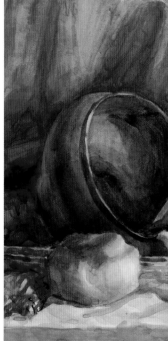

Adding colour

One of the best things about still lifes is that the subject doesn't move, so you have the luxury of time. You can really plan your colour carefully, allowing for drying time between colours if need be. Start from light to dark, paying careful attention to the lighting and how this affects your colour. The colour should really bring your subject to life.

106

Painting flowers

Flowers are one of the most popular still life subjects. Their vibrant colours and unique foliage make them interesting subjects. The softness of watercolour paints lends itself perfectly to painting flowers. As a watercolourist, you should strive to bring the flowers to life. To do this, it isn't necessary to paint every part of the flower in the finest detail. Instead, concentrate the detail in the focal area of the flowers and leave the rest more loose. Try to avoid using masking fluid on flowers – working with the negative spaces can create a softer finish that is more suited to flowers.

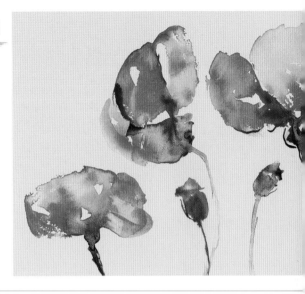

Flowers and vases

If you are painting flowers in a vase, be careful not to split your painting in two with the flowers in the top half and the vase in the bottom half. Try to marry the two halves together by letting a leaf or stem fall across the vase or by lying a petal next to the vase. Remember too that your vase will have water in it. You will need to capture the ellipse of the water line and the colours that can be seen through the water.

Templates

By now, you should have a good understanding of the basics of painting with watercolours, but true artistic talent comes with practise. The following pages are some templates for you to copy, allowing you to put into practise and improve your new skills.

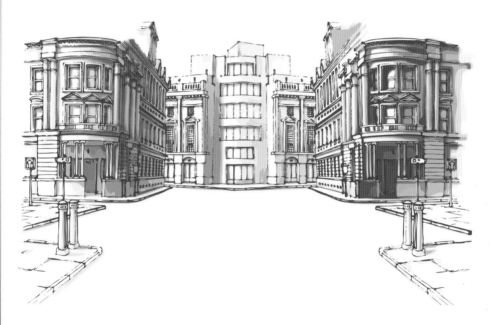

Subject

Choose from beautiful flowers, charming animals, stunning landscapes and delightful nature scenes. These templates can be photocopied or traced onto the surface that works best for you. This means that you can concentrate on improving your painting, finding techniques that suit you and identifying colour blends that show off your personality. You can reuse your templates and try a variety of different colours and techniques on the same image in order to identify what works best. By tracing the scenes you can also experiment with different pencils and drawing methods so that you can confidently sketch your own pictures. These templates are here to be reused time and time again, until you are assured in your abilities.

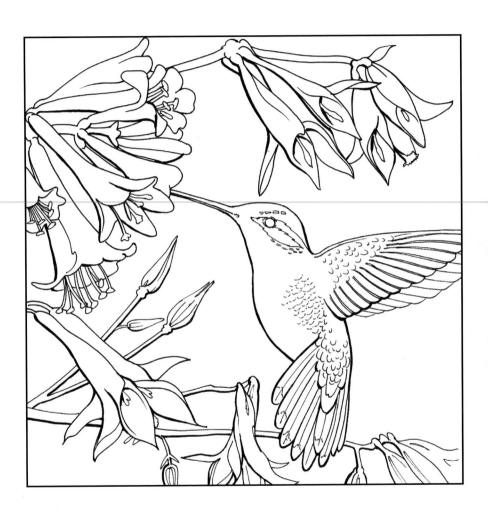

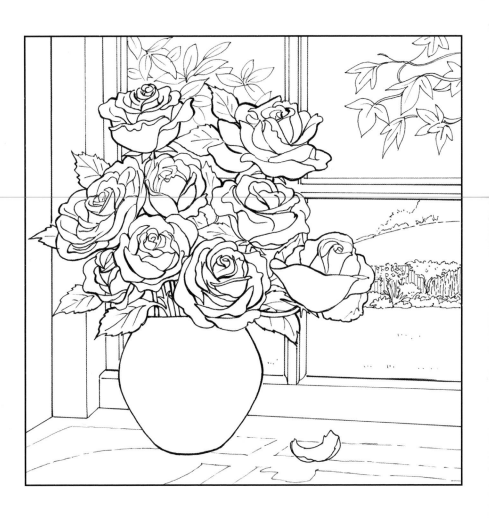

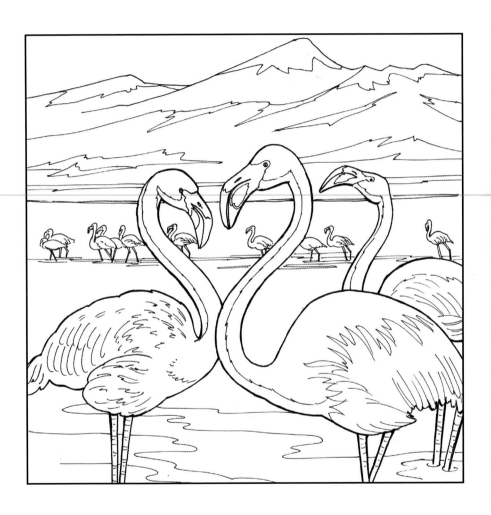

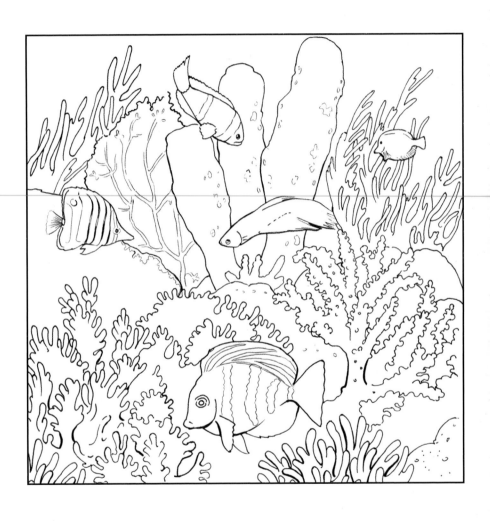

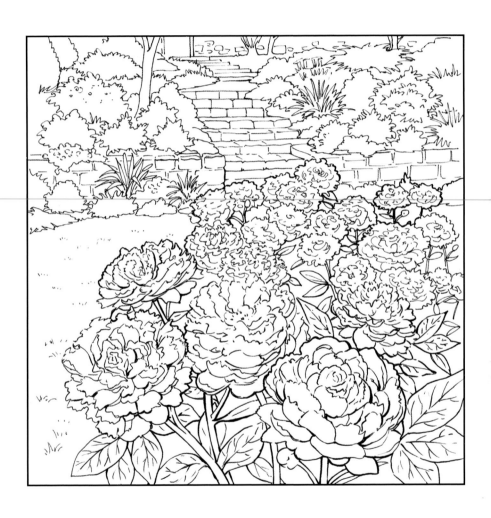

Index

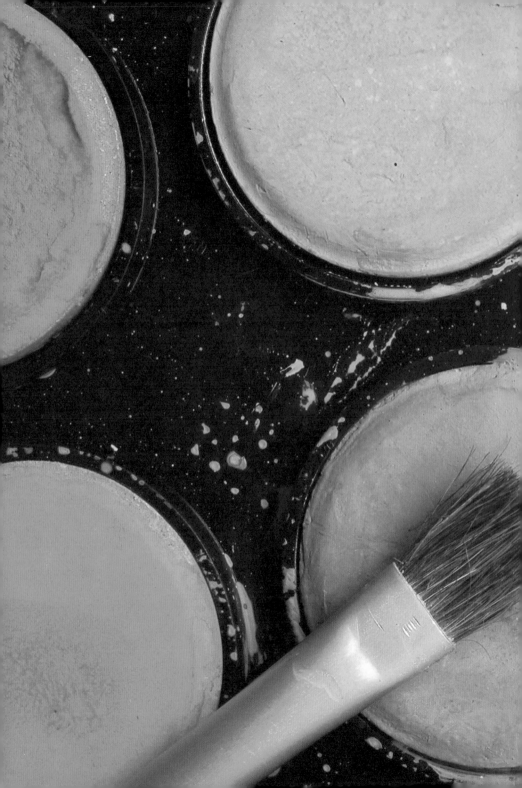